WILLIAM SAHIR HOUSE ART BOOK

WILLIAM SAHIR HOUSE ART BOOK

William Sahir House

Copyright © 2012 by William Sahir House.

ISBN: Softcover 978-1-4691-8639-9

All rights reserved. No part of this book may be reproduced or transmitted in any form or by any means, electronic or mechanical, including photocopying, recording, or by any information storage and retrieval system, without permission in writing from the copyright owner.

This book was printed in the United States of America.

Rev. date: 02/22/2013

To order additional copies of this book, contact:
Xlibris Corporation
1-888-795-4274
www.Xlibris.com
Orders@Xlibris.com
111029

Contents

Anaconda .. 11
Cobra .. 13
Rattlesnake ... 14
Python ... 16
Caracal .. 17
Lynx ... 18
Bobcat ... 20
Cougar ... 22
Jaguar .. 24
Leopard ... 26
Gray Wolf .. 28
Fox ... 30
Wildcat .. 31
Ocelot .. 33
Eagle .. 34
Hawk ... 36
Falcon .. 38
Cardinal ... 40
Blue Jay ... 42
Tiger Shark ... 44
Great White Shark ... 46

DEDICATION

I dedicate this book to every artist who loves the art of drawing and using their craft and skill to bring art to life.

Acknowledge

I thank Xlibris for publishing my art book for distribution and I thank xlibris for graphic designing, book cover designing and publishing my book for distribution.

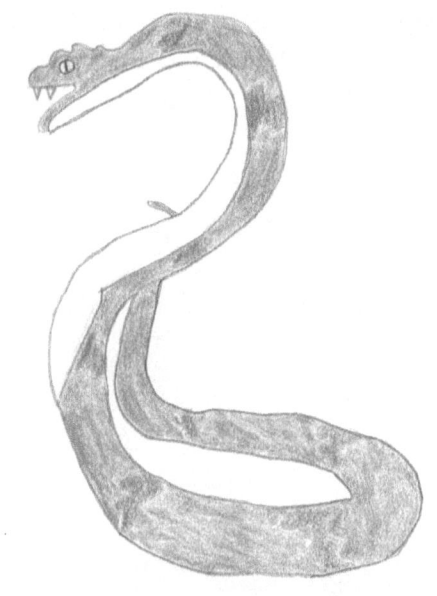

ANACONDA

An anaconda is a large, no venomous snake found in tropical South America. Although the name actually applies to a group of snakes, it's often used to refer only to one species in particular, the common or green anaconda, which is one of the largest snakes in the world. A group of large, aquatic snakes found in South America, the green anaconda, the largest species, is found east of the Andes in Colombia, Venezuela, the Guiana's, Ecuador, Peru, Bolivia, Brazil and on the island of Trinidad. The yellow anaconda, a smaller species, is found in eastern Bolivia, southern Brazil, Paraguay and northeastern Argentina. The dark-spotted anaconda is a rare species found in northeastern Brazil and coastal French Guiana. The Bolivian anaconda, the most recently defined species,

is found in the Departments of Benin and Pando in Bolivia. The giant anaconda is a mythical snake of enormous proportions said to be found in South America. Any large snake that crushes its prey, if applied loosely, could be called anaconda.

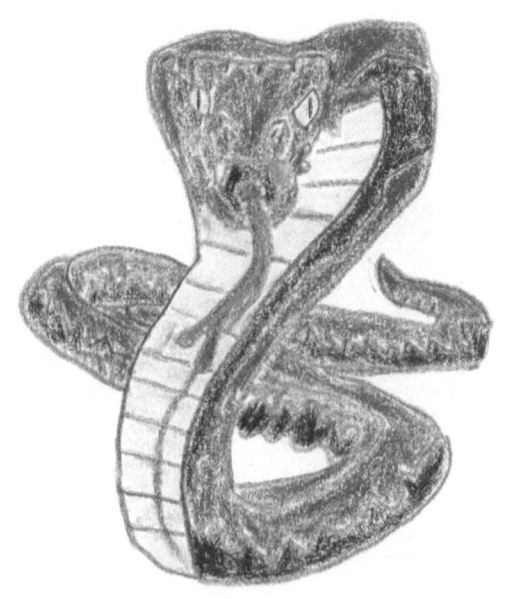

COBRA

Cobra is a venomous snake belonging to the family Lapidate. However, not all snakes commonly referred to as cobras are of the same genus, or even of the same family. The name is short for cobra capo or cape snake, which is Portuguese for snake with hood, or hood-snake. When disturbed, most of these snakes can rear up and spread their neck or hood in a characteristic threat display. Nana, also known as typical cobras with the characteristic ability to raise the front quarters of their bodies off the ground and flatten their necks in a threatening gesture, a group of venomous elapids found in Africa and Asia.

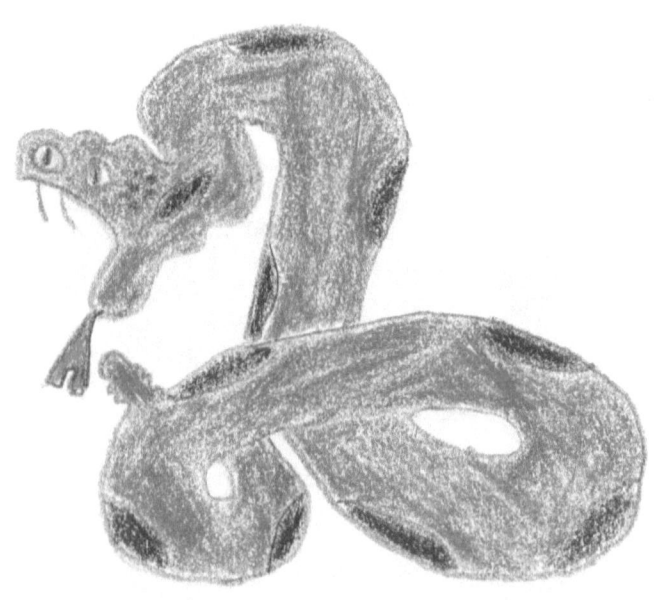

RATTLESNAKE

Rattlesnakes are a group of venomous snakes of the sub family. There are 32 known species of rattlesnake, with between 65-70 subspecies, all native to the Americas, ranging from southern Alberta and southern British Columbia in Canada to Central Argentina. Rattlesnakes are predators that live in a wide array of habitats, hunting small animals such as birds and rodents. They kill their prey with a venomous bite, rather than by constricting. All rattlesnakes possess a set of fangs with which they inject large quantities of hem toxic venom. The venom travels through the bloodstream, destroying tissue and causing swelling, internal bleeding and intense pain. Some species, such as the Mojave Rattlesnake, additionally possess a neurotoxin component in their venom that causes paralysis and other nervous symptoms.

The threat of veneration, advertised with the shaking of the rattle, deters many predators. However, rattlesnakes fall prey to hawks, weasels, king snakes and a variety of other species. Rattlesnakes are heavily preyed opened as neonates, while they are still weak and mentally immature. Very large numbers of rattlesnakes are killed by humans. Rattlesnakes populations in many areas are severely threatened by habitat destruction, poaching and extermination campaigns.

Rattlesnake's bites are the leading causes of snakebite injuries in North America and cause approximately 82% of fatalities. However, rattlesnakes rarely bite unless provoked or threatened; and if treated promptly, the bites are rarely fatal.

PYTHON

Python is a genus of non-venomous pythons found in Africa, Asia and Australia. Currently, 7 species are recognized. A member of this group, Pythons are among the longest snakes known. Found in Africa in the tropics south of the Sahara, but not in southern Africa, the extreme southern western tip, or in Madagascar. In Asia it is found from Bangladesh, Nepal, India, Pakistan and Sri Lanka, including the Nicobar Islands, through Myanmar, east to Indochina, southern China, Hong Kong and Hainan, as well as in the Malayan region of Indonesia and the Philippines. Pythons are both invasive species in North America and they are becoming quite abundant in South Florida and the Everglades.

CARACAL

The caracal is a fiercely territorial medium-sized cat ranging over Western Asia, South Asia and Africa. Although it has traditionally had the alternative names Persian Lynx, Egyptian Lynx and African Lynx, it is no longer considered to be an actual lynx. Instead, it is now believed to be closely related to the African golden cat and the serval. The caracal is classified as a small cat, yet is amongst the heaviest of all small cats, as well as the quickest, being nearly as fast as the serval.

LYNX

A lynx is any of the four lynx genus species of medium-sized wildcats. The name lynx originated in Middle English, in reference to the luminescence of its reflective eyes. There is considerable confusion about the best way to classify felids at present and some authorities classify them as part of the genus felis. Neither the Caracal, sometimes called the Persian Lynx or African Lynx, nor the jungle cat called the swamp lynx, is a member of the lynx genus. Lynx have short tails and characteristic tufts of black hair on the tip of their ears. They have a ruff under the neck, which has black bars, resembling a bow tie. They have large padded paws for walking on snow and long whiskers on the face. The large body

color varies from medium brown to gold-ish to beige-white; and occasionally, is marked with dark brown spots, especially on the limbs. All species of lynx also have white fur on their chests, bellies and on the insides of their legs.

BOBCAT

The bobcat is a North American mammal of the cat family felidae, appearing during the Irvingtonian stage of around 1.8 million years ago (AEO). With twelve recognized subspecies, it ranges from southern Canada to northern Mexico, including most of the continental United States. The bobcat is an adaptable predator that inhabits wooded areas, as well as semi-desert, urban edge, forest edges and swampland environments. It persists in much of its original range and populations are healthy. With a gray to brown coat, whiskered face and black-tufted ears, the bobcat resembles the other species of the mid-sized Lynx genus. It is smaller on average than the Canada Lynx, with which it shares parts of its range, but is about twice as large as the domestic cat. It has distinctive black bars on its forelegs and a black-tipped, stubby tail, from which it derives its name.

Though the bobcat prefers rabbits and hares, it will hunt anything from insects and small rodents to deer. Prey selection depends on location habitats, season and abundance. Like most cats, the bobcat, the bobcat is territorial and largely solitary, although there is some overlap in homes ranges. It uses several methods to mark its territorial boundaries, including claw marks and deposits of urine or feces. The bobcat breeds from winter into spring and has a gestation period of about two months.

Although bobcats have been hunted extensively by humans, both for sport and fur, their population has proven resilient. The elusive predator features in Native American mythology and the folklore of European settlers.

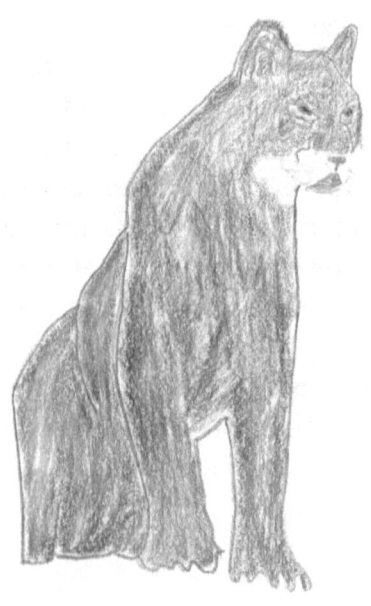

COUGAR

The cougar also known as puma, mountain lion, mountain cat, catamount or panther, depending on the region, is a mammal of the family Felidae, native to the Americas. This large, solitary cat has the greatest range of any large of any large wild terrestrial mammal in the Western Hemisphere, extending from Yukon in Canada to the southern Andes of South America. An adaptable, generalist species, the cougar is found in every major American habitat type. It is the second heaviest cat in the Western Hemisphere, after the jaguar. Although large, the cougar is most closely related to smaller felines and is closer genetically to the domestic cat than to true lions.

A capable stalk and ambush predator, the cougar pursues a wide variety of prey. Primary food sources include ungulates such

as deer, elk, moose and bighorn sheep, as well as domestic cattle, horses and sheep, particularly in the northern part of its range. It will also hunt species as small as insects and rodents. This cat prefers habitats with dense underbrush and rocky areas for stalking, but it can also live in open areas. The cougar is territorial and persists at low population densities. Individual territory sizes depend on terrain, vegetation and abundance of prey. While it is large predator, it is not always the dominant species in its range, as when it competes for prey with other predators such as the jaguar, grey wolf, American Black Bear and the grizzly bear. It is a reclusive cat and usually cat avoids people. Attacks on humans remain fairly rare, despite a recent increase in frequency.

Because of excessive hunting following the European colonization of the Americas and the continuing human development of cougar habitat, populations have dropped in most parts of its historical range. In particular, the cougar was extirpated in eastern North America in the beginning of the 20th century, except for an isolated sub-population in Florida. However, in recent decades, breeding populations have moved east into the far western parts of the Dakotas, Nebraska and Oklahoma. Transient males have been verified in Minnesota, Wisconsin, Iowa, the Upper Peninsula of Michigan and Illinois, where a cougar was shot in the city limits of Chicago and in at least one instance, observed as far east as Connecticut.

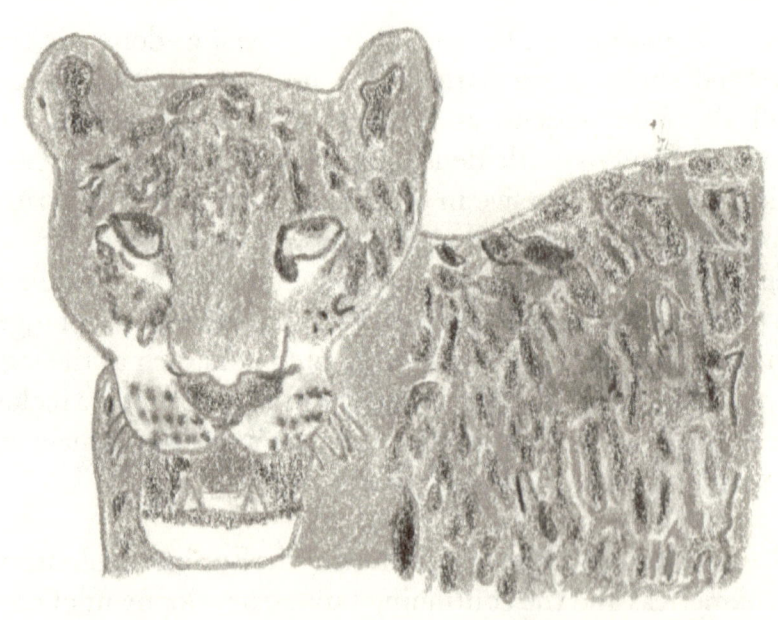

JAGUAR

The jaguar is a big cat, a feline in the Panther a genus and is the only Panther a species found in the Americas. The jaguar is the third-largest feline after the tiger and the lion and the largest in the Western Hemisphere. The jaguar's present range extends from Southern United States and Mexico across much of Central America and south to Paraguay and northern Argentina. Apart from a known and possibly breeding population in Arizona, the cat has largely been extirpated from the United States since the early 20th century.

This spotted cat most closely resembles the leopard physically, although it is usually larger and of sturdier build and its behavior and habitat characteristics are closer to those of the tiger. While dense rainforest is its preferred habitat, the jaguar will range across

a variety of forested and open terrain. It is strongly associated with the presence of water and is notable, along with the tiger, as a feline that enjoys swimming. The jaguar is largely a solitary, opportunistic, stalk and ambush predators at the top of the food chain. It is a keystone species, playing an important role in stabilizing ecosystems and regulating the populations of the animals it hunts. The jaguar has an exceptionally powerful bite, even relative to the other big cats. This allows it is pierce the shells of armoire reptiles and to employ an unusual killing method: it bits directly through the skull of prey between the ears to deliver a fatal bite to the brain.

The jaguar is a near threatened species and its numbers are declining. Threats include habitat loss and fragmentation. While international trade in jaguars or their parts is prohibited, the cat is still frequently killed by humans, particularly in conflicts with ranchers and farmers in Southern America. Although reduced, its range remains large; given its historical distribution, the jaguar has featured prominently in the mythology of numerous indigenous American cultures, including that of the Maya and Aztec.

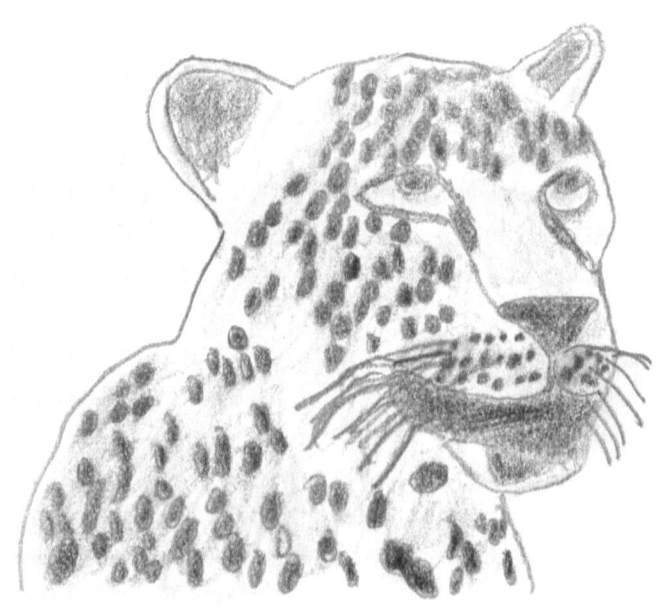

LEOPARD

The leopard is a member of the felidae family and the smallest of the four big cats in the genus Panthera, the other three being the tiger, lion and jaguar. The leopard was once distributed across eastern and southern Asia and Africa, from Siberia to South Africa, but its range of distribution has decreased radically because of hunting and loss of habitat. It is now chiefly found in Sub-Saharan Africa; there are also fragmented populations in the Indian subcontinent, Sri Lanka, Indochina, Malaysia, Indonesia and China because of its declining range and population, it is listed as near threatened species on the IUCN red list.

Compared to other members of the Felidae family, the leopard has relatively short legs and a long body with a large skull. It is similar in appearance to the jaguar, but is smaller and more slightly

built. Its fur is marked with rosettes similar to those of the jaguar, but the leopard's rosettes are smaller and more densely packed and do not usually have central spots as the jaguars do. Both leopards and jaguars that are completely black or very dark are known as black panthers.

The species success in the wild is in part due to its opportunistic hunting behavior, its adaptability to habitats, its ability to run at speeds approaching 58 kilometers per hour (36 mph), its unequaled ability to climb trees even when carrying a heavy carcass and its notorious ability for stealth. The leopard consumes virtually any animal that it can hunt down and catch. Its habitat ranges from rainforest to desert terrains.

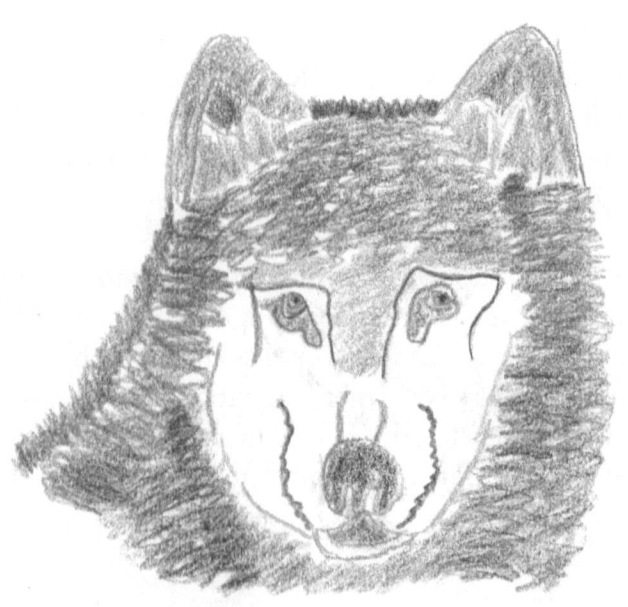

GRAY WOLF

The gray wolf is the largest extant member of the dog family of mammals, the Canidae. The species was the world's most widely distributed mammal, but has become extinct in much of Western Europe, in Mexico and much of the USA. Wolves occur primarily, but not exclusively in wilderness and remote areas. Their original worldwide range has been reduced by about one-third by deliberate persecution due to depredation on livestock and fear of attacks on humans. Although the species still faces some threats, it is relatively widespread with a stable population trend and has therefore been assessed at least concern by IUCN since 2004.

Though once abundant over much of Eurasia, North Africa and North America, the gray wolf inhabits a reduced portion of it former range due to widespread destruction of its territory, human

encroachment and the resulting human-wolf encounters that Sparked broad extirpation. Today, wolves are protected in some areas, hunted for sport in others, or may be subjected to population control or extermination as threats to livestock, people and pets.

Gray wolves are social predators that live in nuclear families consisting of a mated pair, their offspring and occasionally, adopted immature wolves. They primarily feed on ungulates, which they hunt by wearing them down in short chases. Gray wolves are typically apex predators throughout their range, with only humans and tigers posing significant threats to them. In areas where human cultures and wolves both occur, wolves frequently feature in the folklore and mythology of those cultures, both positively and negatively.

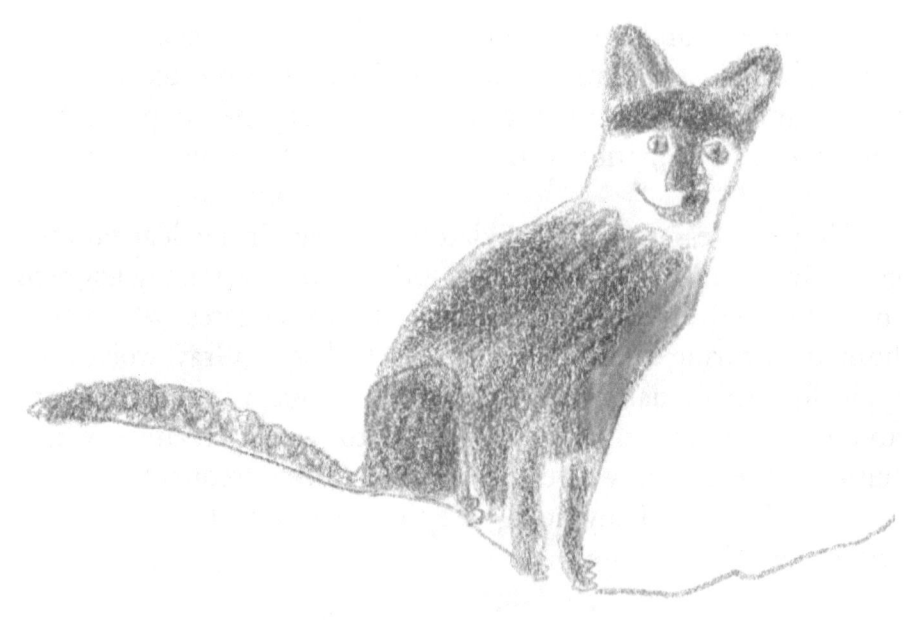

FOX

Fox is a common name for many species of omnivorous mammals belonging to the Canidae family. Foxes are small to medium-sized canids, characterized by possessing a long narrow snout and a bushy tail. Members of about 37 species are referred to as foxes, of which only 12 species actually belong to the true foxes. By far the most common and widespread species of fox is the red fox, although various species are found on almost every continent. The presence of fox-like carnivores all over the globe, together with their appearance in popular culture and folklore in many societies around the world.

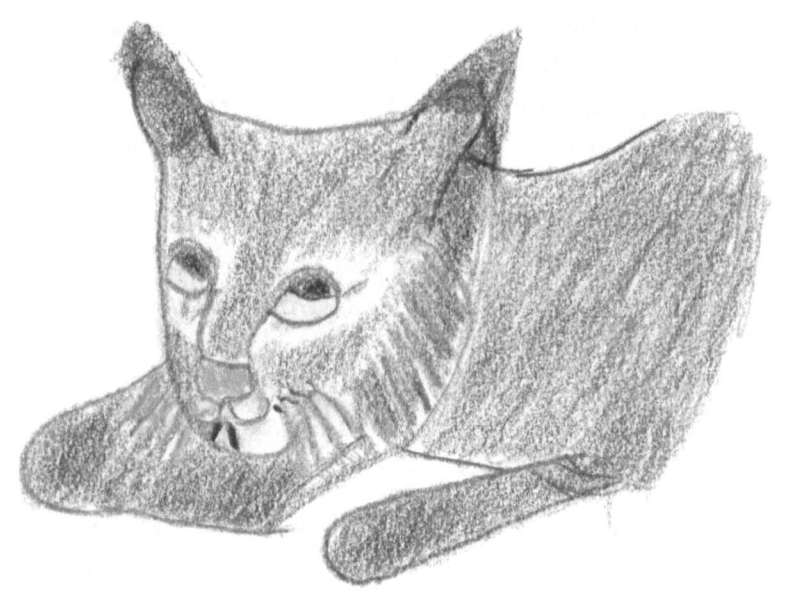

WILDCAT

The wildcat is a small cat with several subspecies and a very broad distribution, found throughout most of Africa, Europe and southwest and central Asia into India, China and Mongolia. It is a hunter of small mammals, birds and other creatures of a similar or smaller size. Sometimes included is the ubiquitous domestic cat, which has been introduced to every habitable continent and most of the world's larger islands and has become feral in many of those environments.

In its native environment, the wildcat is adaptable to a variety of habitat types: savannah, open forest and steppe. Genetic, morphological and archaeological evidence suggests that the housecat was domesticated from the African wildcat, probably 9-10,000 years ago in the Fertile Crescent region of the Near east,

coincident with the rise of agriculture and the need to protect harvest from grain-eating rodents. This domestication probably occurred when grain was yielded from the Agricultural Revolution onwards, which was stored in granaries that attracted rodents, which in turn attracted cats.

The closest relative of the wildcat is the sand cat. The wildcat physically resembles a domesticated cat in most respects. Although domesticated breeds show a great variety of shapes and colors, wild species are pale yellow to medium.

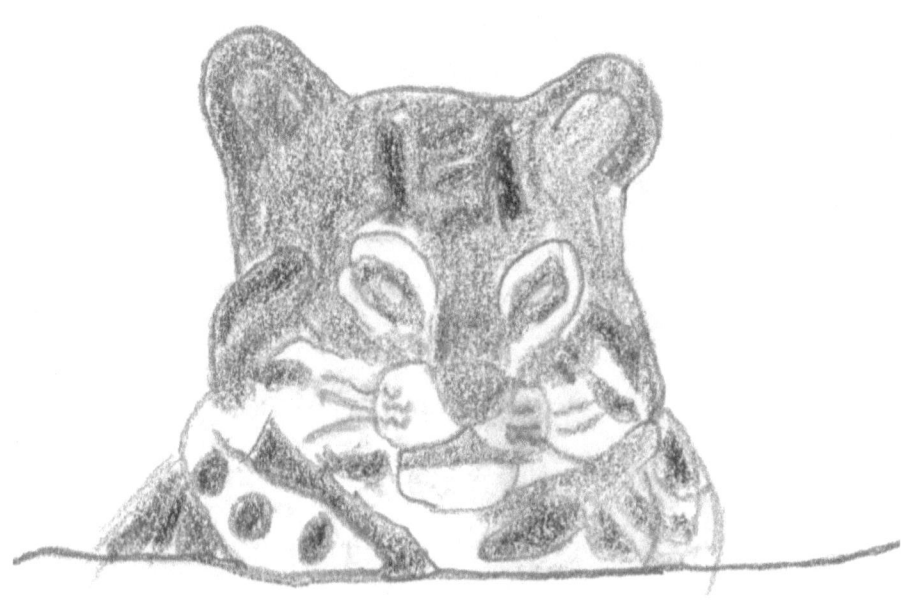

OCELOT

The ocelot is a wild cat distributed over South and Central American and Mexico, but has been reported as far north as Texas and in Trinidad, in the Caribbean. North of Mexico, it is found regularly only in the extreme southern part of Texas, although there are rare sightings in Southern Arizona.

The ocelot is similar in appearance to a domestic cat. Its fur resembles that of a clouded leopard or jaguar and was once regarded as particularly valuable. As a result, hundreds of thousands of ocelots were once killed for their fur. The feline was classified a vulnerable endangered species from 1972 until 1996, but is now rated least concern by the 2008 IUCN Red list.

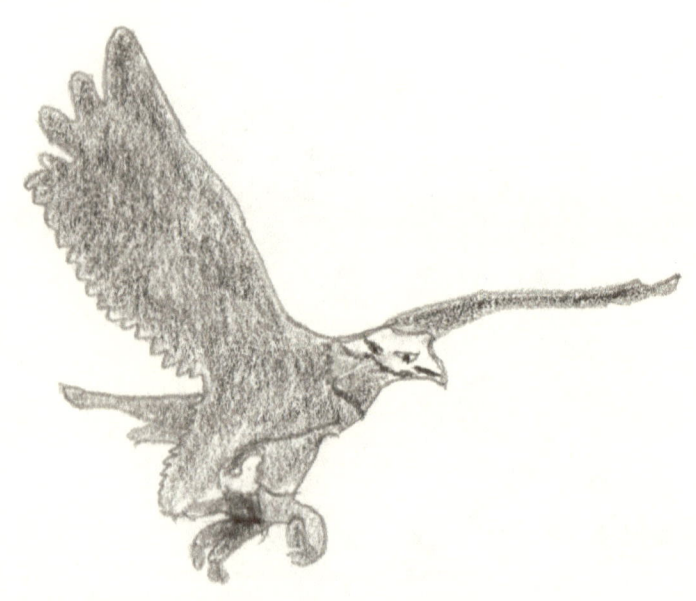

EAGLE

Eagle is members of the bird family and belong to several genera which are not necessarily closely related to each other. Most of the more than 61 species occur in Eurasia and Africa. Outside this area, just two species can be found in the United States and Canada, nine more in Central and South America and three in Australia. Many different species of eagle are found in the Philippines.

Eagles are large, powerfully built birds of prey, with a heavy head and beak. Even the smallest eagles, like the Booted Eagle, have relatively longer and more evenly broad wings and more direct, faster flight. Most eagles are larger than any other raptors apart from some vultures. Like all birds of prey, eagles have very large hooked beaks for tearing flesh from their prey, strong muscular legs and powerful talons. The beak is typically heavier than most

other birds of prey. They also have extremely keen eyesight which enables them to spot potential prey from a very long distance. This keen eyesight is primarily contributed by their extremely large pupils which minimal diffraction of the incoming light.

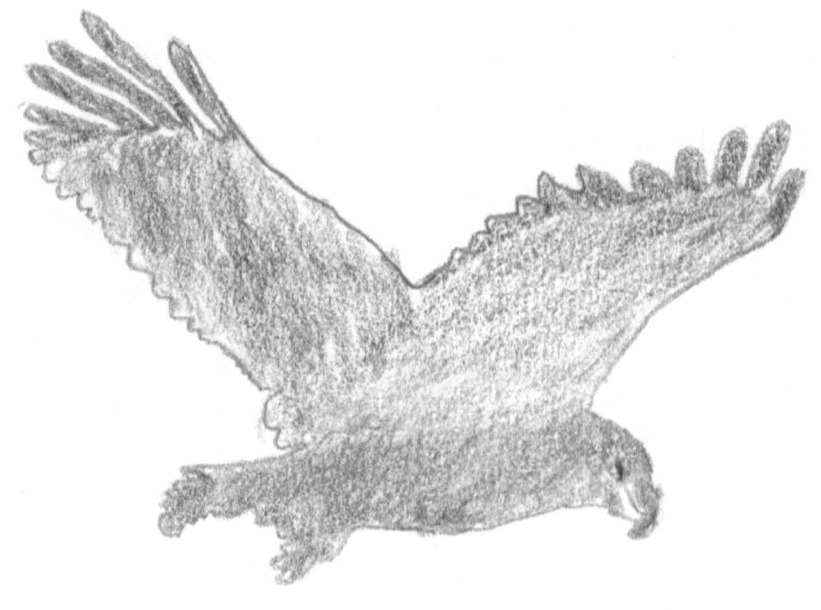

HAWK

In strict usage in Australia and Africa, to mean any of the species in the subfamily, the large and widespread genus includes goshawks, sparrow hawk, the Sharp-shinned Hawk and others. These are mainly woodland birds with long tails and high visual acuity, hunting by sudden dashes from a concealed perch. More generally to mean falcons or small to medium-sized members of the subfamily, the family which includes the true hawks as well as eagles, kites, harriers and buzzards. Loosely, to mean almost any bird of prey outside of the order owls.

The common names of birds in various parts of the world often use hawk in the second sense. For example, the Osprey or fish hawk; or, in North American, hawks were name among the most intelligent bird based on his scale. Hawks are widely reputed to have visual acuity several times that of a normal human being.

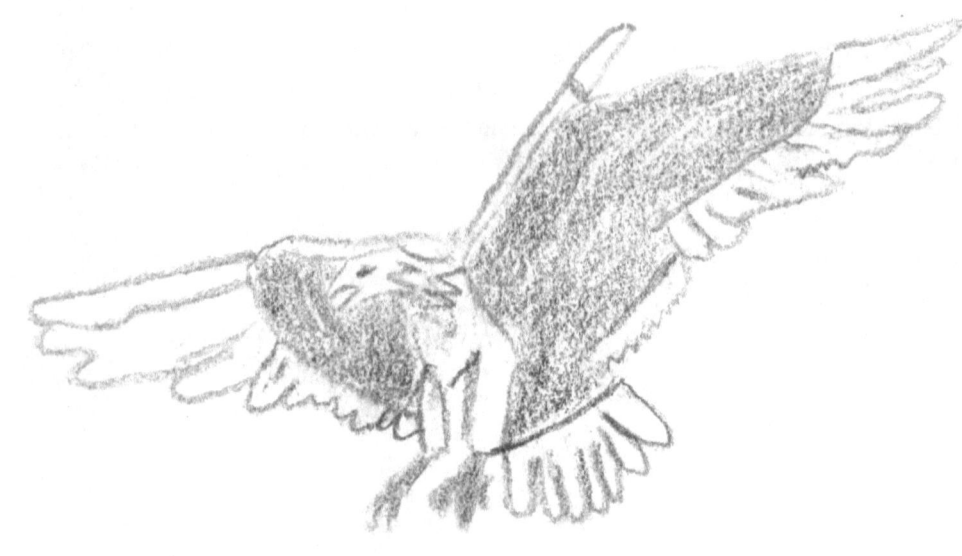

FALCON

A falcon is any species of raptor in the genus. The genus contains 37 species, widely distributed throughout Europe, Asia and North America. Adult falcons have thin tapered wings, which enable them to fly at high speed and to change direction rapidly. Fledgling falcons, in their first year of flying, have longer flight feathers which makes their configuration more like that of a general-purpose bird such as a broad wing. This makes it easier to fly while learning the exceptional skills required being effective hunters as adults.

Peregrine Falcons have been recorded diving at speeds of 200 miles per hour, making them the fastest-moving creatures on earth. Other falcons include the Gyrfalcon, Lanner Falcon and the Merlin. Some small falcons with long narrow wings are called

hobbies and some which hover while hunting are called kestrels. The falcons are part of the family Falconidae, which also includes the caracaras, laughing falcon, forest falcons and falconets.

The traditional term for a male falcon tersely because of the belief that only one in three eggs hatched a male bird. Some sources give the etymology as deriving from the fact that a male falcon is approximately one third smaller than the female. A falcon chick, especially one reared for falconry, that is still in its downy stage is known as an eyes. The technique of hunting with trained captive birds of prey is known as falconry. As is the case with many birds of prey, falcons have exceptional powers of vision; the visual acuity of one species has been measured at 2.6 times that of a normal human.

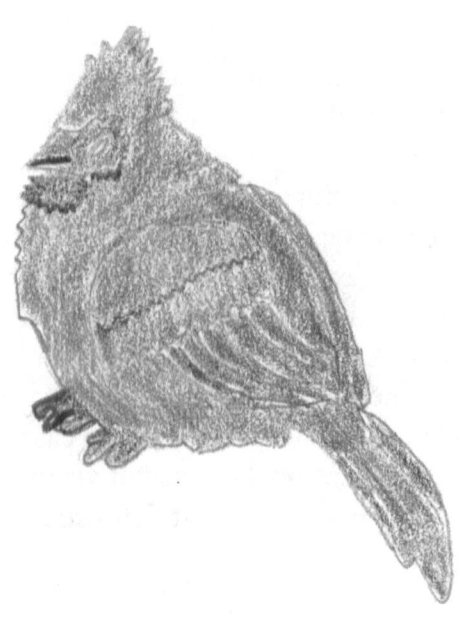

CARDINAL

The Cardinals are a family of passerine birds found in North and South America. The South American cardinals in the genus are placed in another family. These are robust, seed-eating birds with strong bills. The family ranges in sized from the 12-cm, 11.5-gram Orange-breasted Bunting to the 25-cm, 85-gram Black-headed Salutatory. They are typically associated with open woodland. The sexes usually have distinctive appearances; the family is named for the red plumage of males of the type species, the Northern Cardinal.

The buntings in this family are sometimes generically known as tropical buntings or North American buntings to distinguish them from the true buntings. Likewise the grosbeaks in this family

are sometimes called cardinal-grosbeak to distinguish them from other grosbeaks. The name cardinal-grosbeak can also apply to this family as a whole. Most species are rated by the IUCN as least concern, though some are near threatened.

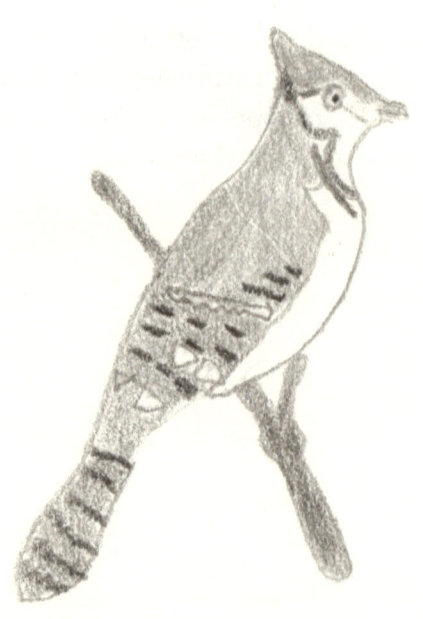

BLUE JAY

The Blue Jay is a passerine bird in the family, native to North America. It is resident through most of eastern and central United States and southern Canada, although western populations may be migratory. It breeds in both deciduous and coniferous forest and is common near and in residential areas. It is predominately blue with a white breast and under parts and a blue crest. It has a black, U-shaped collar around its neck and a black border behind the crest. Sexes are similar in size and plumage and plumage does not vary throughout the year. Fear subspecies of the Blue Jay are recognized.

The Blue jay mainly feeds on nuts and seeds such as acorns, soft fruits, arthropods and occasionally small vertebrates. It typically gleans food from trees, shrubs and the ground, though it sometimes hawks insects from the air. It builds an open cup nest in the branches of a tree.

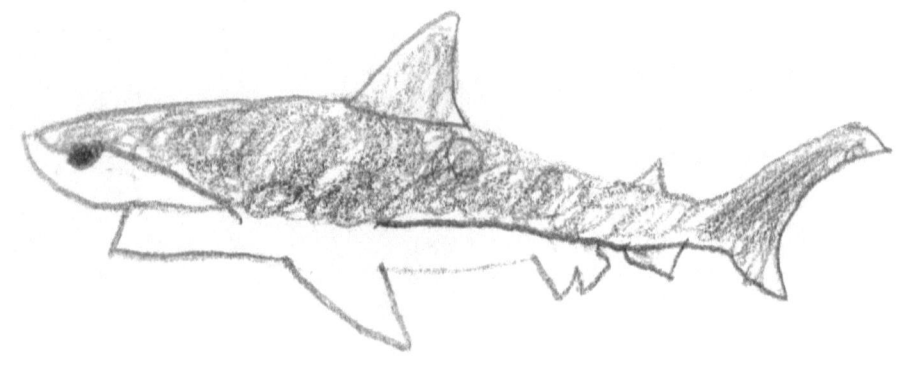

TIGER SHARK

The tiger sharks, is a species of requiem shark and the only member of the genus. Commonly known as sea tigers, tiger sharks are relatively large macro predators. Capable of attaining a length of over 5m (16 ft). It is found in many tropical and temperate waters and is especially common around central Pacific islands. Its name derives from the dark stripes down its body which resemble a tiger's pattern and fade as the shark matures.

The tiger shark is a solitary, mostly night-time hunter. Its diet involves a wide range of prey, including crustaceans, fish, seals, birds, smaller sharks, squids, turtles, sea snakes, and dolphins. The tiger shark is considered a near threatened species due to fining and fishing by humans.

While the tiger shark is considered to be one of the sharks most dangerous to humans, the attack rate is surprisingly low according to researchers. The tiger is second on the list of number of recorded attacks on humans, with the great white shark being first. They often visit shallow reefs, harbors and canals, creating the potential for encounter with humans.

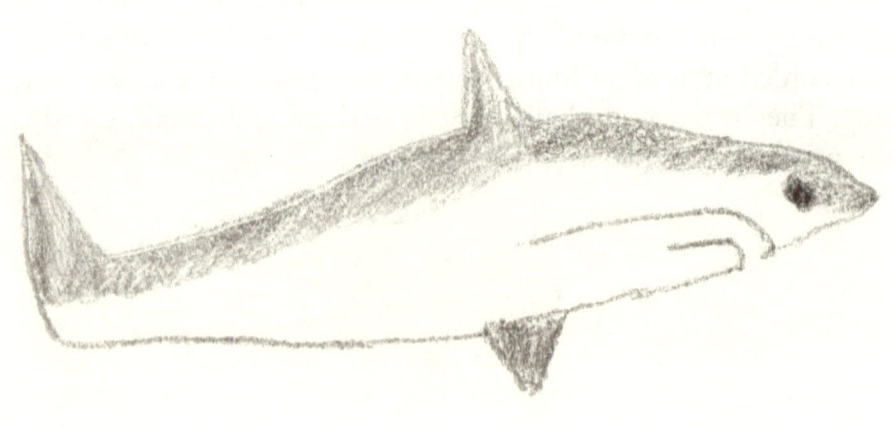

GREAT WHITE SHARK

This shark reaches maturity at around 15 years of age and can have a life span of over 30 years. The great white shark is arguably the world's largest known extant macro predatory fish and is one of the primary predators of marine mammals. It is also known to prey upon a variety of other marine animals including fish, pinnipeds and seabirds. It is the only known surviving species of its genus and is ranked first in a list of number of recorded attacks on humans.

www.ingramcontent.com/pod-product-compliance
Lightning Source LLC
Chambersburg PA
CBHW021050180526
45163CB00005B/2359